CHRISTIE'S
COLLECTABLES

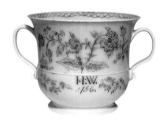

CHRISTIE'S
COLLECTABLES

BLUE AND WHITE
CHINA

Paul Tippett

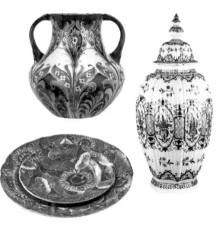

LITTLE, BROWN AND COMPANY
BOSTON NEW YORK LONDON TORONTO

A LITTLE, BROWN BOOK

FIRST PUBLISHED IN GREAT BRITAIN IN 1997
BY LITTLE, BROWN AND COMPANY (UK)

CONCEIVED, EDITED AND DESIGNED BY
MARSHALL EDITIONS
170 PICCADILLY LONDON W1V 9DD

A CIP catalogue record for this book is available
from the British Library.

ISBN 0-316-64078-6

2 4 6 8 10 9 7 5 3 1

PROJECT EDITOR THERESA LANE
PROJECT ART EDITOR HELEN SPENCER
PICTURE EDITOR ELIZABETH LOVING

Originated in Italy by Ad Ver, Bergamot
Printed and bound in Portugal by Printer Portuguesa

LITTLE, BROWN AND COMPANY (UK)
Brettenham House Lancaster Place London WC2E 7EN

CHRISTIE'S
8 King Street St. James's London SW1Y 6QT

CHRISTIE'S SOUTH KENSINGTON
85 Old Brompton Road London SW7 3LD

CHRISTIE'S
502 Park Avenue New York NY 10022

CHRISTIE'S AUSTRALIA
180 Jersey Road Woollahra Sydney NSW 2025

CHRISTIE'S SOUTH AFRICA
P.O. Box 72126 Parkview Johannesburg 2122

CHRISTIE'S JAPAN
Sankyo Ginza Building 6-5-13 Ginza Chuo-ku Tokyo 104

Contents

PRICE CODES

The following price codes are used in this book:
£A Less than £150 **£B** £151–£500 **£C** £501–£2,500
£D £2,501–£7,500 **£E** £7,501–£15,000
£F £15,001–£50,000 **£G** More than £50,000

Valuation is an imprecise art and prices can vary for many
reasons, including the condition of a piece, fashion and national and
regional interest. Prices given in this book are approximate
and based on likely *auction* values. *Insurance* values reflect the
retail replacement price and as such are liable to be higher.

Introduction

THE CHINESE INVENTED PORCELAIN AND THE PERSIANS supplied the cobalt to decorate it. It is these two elements, from different cultures and traditions, that have provided the world with "blue and white" – pottery and porcelain distinctively decorated in only these colours – and it has remained popular for centuries.

There is something special about blue and white pottery and porcelain. It appeals to people from all parts of the world and from all walks of life. This is because, in its first incarnation as Chinese porcelain, it was a

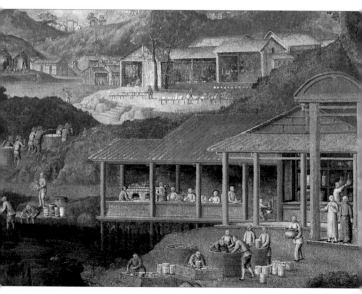

The various stages of making pottery are shown in this illustration from the Chinese School, c.1800.

This rare moonflask (1403–24) from the Ming dynasty is an excellent example of skilfully applied and delicate painting.

rare commodity, available only to the rich. Today, it is accessible to almost everyone – but no matter where it is produced, it is associated, probably unconsciously, with the original precious Chinese porcelain.

Chinese porcelain was first made in the seventh century from a combination of local, naturally occurring china clay, feldspar and flint. This combination, when heated to an extremely high temperature, fused to form true porcelain. The china clay was the key to success, helped by the fact that centuries beforehand, the Chinese had also developed the right kiln technology. The first blue and white porcelain wares were made when Persian cobalt was imported into China in the 13th century and used to decorate underglaze. In the following two or three centuries, blue and white porcelain was exported to Europe, where nothing of the kind could be made, and was greatly admired. It also spread to Japan, where it met with similar admiration, and the Japanese, in turn, learned to make it.

As the first European traders, the Portuguese made contact with the Far East in the 16th century; they established trading posts and arranged regular shipments to Europe. It did not take long for first the

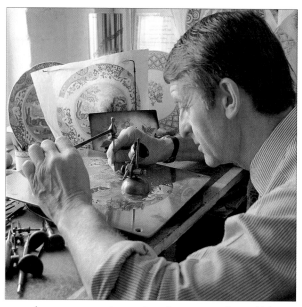

An engraver creates a pattern in a copper plate, which will be used to make transfer prints.

Chinese, then the Japanese, to realize the potential of the market, and production was increased. The first major cargoes from ships containing nothing but porcelain arrived in Europe in the early 17th century.

*O*riental blue and white porcelain transformed the European perception of what ceramics should be. Until this time, the Europeans had known only earthenwares and stonewares. "Chinamania" took hold in the 17th century, with monarchs – most notably Queen Mary at Hampton Court – filling their palaces with blue and white. It also changed the European ceramics industry. The delftware patterns changed in style overnight; only Chinese or Japanese blue and white patterns would do.

Europeans redoubled their efforts to make porcelain, which they achieved in the early 1700s.

The 18th century witnessed the Industrial Revolution. The making of porcelain had been established, and there then ensued an explosion of technological discoveries in all fields of ceramics production from the middle until the end of the century. First it became easy to make blue and white; the next step was to mass-produce it. Great Britain was one of the leaders in this field. It was there, in the 1750s, that transfer-printing overglaze on pottery was invented (although only in limited colours, and excluding blue); by 1759, potters were applying under-glaze blue transfer prints to porcelain. And by 1784,

A woman studies a vase from her collection of blue and white porcelain, in this 19th-century painting by the artist Ellen Clacy.

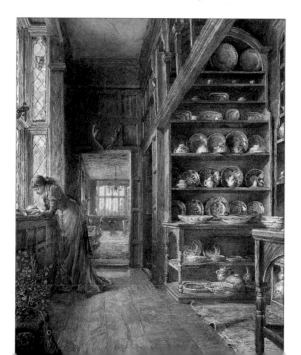

Spode had perfected underglaze blue transfer printing on earthenware. The British factories exported the new incarnation of blue and white all over the world; at last, it was accessible to everyone.

*D*own the centuries blue and white has shown great staying power and the ability to reinvent itself constantly for different cultures and times. Old designs have been updated, reinterpreted, or have resurfaced to become timeless classics. Each generation has found a new way to appreciate an ancient art form. Blue is the world's favourite colour, and displayed against white it looks brighter than ever, a combination that has basic aesthetic appeal worldwide.

To produce the pattern on a piece, a transfer is being positioned on a bowl, which will then be glazed and fired.

TIPS FOR COLLECTORS

• Read about the subject's history. Most general books on ceramics will give a good grounding in blue and white. This helps to date and attribute pieces correctly.

• Learn how a piece is made, what materials were used and which techniques were employed for decoration. These can provide clues to the age and origin of a piece.

• A good way to learn, even if you do not buy, is to go to public viewings before an auction. Look at the objects and consult the auction house catalogue.

• Decide what you like best and what interests you most. Your tastes are likely to change as your knowledge increases, so an occasional "weeding out" of the collection will be beneficial.

• Meet like-minded people; discuss the subject with them and compare collections. They will help keep you informed of events and exhibitions.

• You will probably buy from antique shops and markets. If you get to know the dealers and they know what you are looking for, they can help you find it.

• If buying from a dealer or an auction house, ask about condition and restoration. If you are not clear about what they tell you, ask for an explanation. It is vital to understand restoration and damage – they can affect the value of the object.

This Moorcroft "Peacock Feather" earthenware vase shows how a traditional Persian motif has been reinterpreted in an Art Nouveau style.

Abbasid pottery

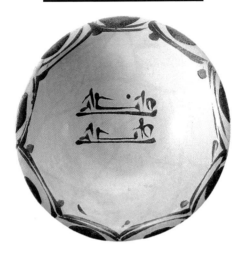

*T*HE ISLAMIC TRADITION OF USING SCRIPT
*as decoration is evident in this 9th-century bowl
from near Baghdad. The Arabic inscription is the
word* baraka, *or blessing, written twice.*
*T*HE BOWL IS MADE OF TIN-GLAZED EARTHENWARE. ITS
*body was shaped on a wheel by hand; it was then
dipped in slip (liquid clay), oxide of tin and,
possibly, oxide of lead. Once this was dry, the
decoration was painted on in cobalt, and the bowl
was fired. The decoration sank into the "tin glaze",
which became a shiny, white surface. Tin
glazing was known to the ancient Egyptians and
was later rediscovered by Arab potters.*
*I*N CREATING A WHITE POTTERY, THE ARABS WERE, PERHAPS,
*imitating Chinese porcelain, first made in the
seventh century. Arab trade links extended all over
the world, and the Arabs were among the first
outside China to see white Chinese porcelain.*
Diameter 8in/20cm £F

Mamluk earthenware

THESE 15TH-CENTURY WALL TILES WERE PROBABLY produced in Damascus, Syria. Earthenware was pressed into moulds and cut out when slightly dry. At this stage the designs were painted on the tiles in cobalt. The tiles were then dipped in glaze (often a lead glaze), which sealed in the design and gave the tiles their reflective surface. This type of decoration is referred to as underglaze blue.

THE PATTERNS ON THE TILES ARE TYPICALLY ISLAMIC. They have a symmetry that reflects the Islamic taste for geometrical ornament, and the flowers, plants and palm trees express a deep love of nature.

TILES ARE CALLED "KASHI" IN ARABIC, AFTER KASHAN, near Teheran in Iran (ancient Persia). Kashan was an important Islamic centre for the production of ceramics. For a long time in the ancient world it was also the only source of cobalt, which was mined in nearby hills.

Width 8in/20cm £C

Iznik pottery

THIS FRITWARE DISH OF C.1530 IS AN IMITATION
of a Chinese dish of c.1400. It was produced
at Iznik in Anatolia, Turkey. Fritware, a type of
artificial, or soft-paste, porcelain, was probably
invented at Kashan. It is made of 10 parts ground
silica, 1 part glass and 1 part clay.

IZNIK BECAME A MAJOR PRODUCTION CENTRE FOR FRITWARE
because of its location on a trade route to Istanbul,
the capital of the Ottoman Empire. The sultans
preferred the best vessels for their table: they
were usually gold or silver or, where possible,
Chinese blue and white porcelain. Fritware tiles
were produced for their mosques and palaces, and
Iznik pottery became prized in its own right.

VISITORS TO TURKEY TOOK FRITWARE HOME WITH
them: it was brought to Great Britain in the
16th century. Some pieces were made for European
patrons and decorated with their coats-of-arms.

Diameter 14½in/37cm £G

Safavid porcelain

*A*N EXAMPLE OF WORK BY *P*ERSIAN POTTERS,
this bowl was produced in the early 17th century,
possibly at Kirman or Kashan, Persia (modern
Iran). It was made of an artificial, or soft-paste,
porcelain, which contains a large amount of glass
and flint and a small amount of white clay –
a formula created centuries earlier. The underglaze
is a Persian cobalt and the glaze is lead based.

*T*HE *P*ERSIANS ADMIRED *C*HINESE BLUE AND WHITE AND
imitated these wares. This bowl is an adaptation
of a Chinese original: it has a Chinese character
mark on the base, as does much of this type of
Persian pottery. However, the potter has
interpreted the designs with some originality.

*E*UROPEAN VISITORS TO *P*ERSIA IN THE 17TH CENTURY
noticed the Persian blue and white pottery, which
they sometimes called faience. Contemporary
accounts record that is was of good quality, but
less able to withstand hot liquids than the stronger
Chinese porcelain. This is a typical difference
between hard-paste and soft-paste porcelains.

Diameter 21in/53.5cm £E

Early Ming flask

THE CHINESE WERE THE FIRST to make fine, white hard-paste porcelain, and they began this craft at Jingdezhen in southern China during the Tang dynasty (618–906). By the mid-14th century it was the most important centre of porcelain production in China. This flask was made at Jingdezhen early in the Ming dynasty (1368–1644). Hard-paste porcelain requires kilns that can be heated to a very high temperature, over 1,250°C (2,300°F), in order for it to vitrify, making it the hard, white, translucent substance that we recognize as porcelain.

IN CHINA, PORCELAIN WAS FIRST DECORATED IN UNDERGLAZE blue sometime before 1300. The early style of painting is sketchy, and the blue can be pale and washed out. Early blue and white porcelain was made only for important commissions – for the imperial court or aristocracy. Phoenixes in flight, the symbol of the Empress, are a typically Chinese design. The geometric decoration on this flask is not typical and probably Persian in origin.

THIS FLASK IS EXTREMELY UNUSUAL: THE POTTERS HAVE copied a Middle Eastern metalwork flask in both the form and the geometrical ornament.

Height 11½in/29cm £G

Ming moonflask

THE SHAPE OF
moonflasks is based
on that of earthenware
water flasks, and
there are metalwork
prototypes, which,
typically, came
from the
Middle East.
This piece
was made at
the Jingdezhen
kilns in China
during the second
century of the Ming
dynasty (1368–1644).
The cobalt used for
decoration on this flask was
not available in China and had to be imported
from Persia (modern Iran).

THE FLOWERS ARE A COMBINATION OF CHINESE AND
Middle Eastern inspiration. The Chinese had been
applying flower designs to their pottery and porcelain
for centuries, sometimes using such techniques
as moulding or incising; they continued this tradition
when they began decorating in underglaze blue.
On this piece, the flowers are in a symmetrical
design reminiscent of Islamic art.

THE JINGDEZHEN KILNS WERE THE MOST IMPORTANT KILNS
making porcelain in China, principally because the
raw materials were to be found nearby. The porcelain
was made from a combination of local clay (kaolin),
feldspar (a crystalline rock) and flint.

Height 10½in/26.5cm £F

Ming porcelain bowl

THIS BOWL FROM JINGDEZHEN, CHINA, WAS MADE in the Ming dynasty, during the reign of Emperor Wanli (1573–1620). The piece has the emperor's reign mark, in Chinese characters, on its base, which can help date it. These reign marks, which first appeared on Chinese porcelain in the early 15th century, are not always an accurate guide for dating. Throughout their history, Chinese potters made reproductions of pieces, including the marks.

To date a piece accurately, many factors must be assessed, such as its style or shape, the quality of the porcelain, the type of decoration and the quality of the painting. This bowl is an original.

IN CHINESE ART, DRAGONS ARE FERTILITY SYMBOLS, THE bringers of rain for the crops. They first appear on Yuan dynasty (1279–1368) wares but are more often seen on Ming wares. Five-clawed dragons were symbols of the emperor. On this bowl, dragons fight for the flaming pearl, which bestows immortality.

Diameter 13¼in/35cm £D

Transitional ewers

SOME PORCELAIN EWERS, such as these of c.1650 from Jingdezhen, China, belong to the so-called Transitional period – a politically unsettled time from 1620 to c.1683. During this period a great deal of Chinese porcelain was exported to the West.

THE FIRST SIGNIFICANT CARGOES of blue and white porcelain were taken by Portuguese merchants to Amsterdam. The earliest recorded shipments, in 1602 and 1604, sold with great success. Discovering that they could sell as much porcelain as they could ship, the merchants encouraged the Chinese to increase production.

THE MASS-PRODUCED BLUE AND WHITE PORCELAIN WAS NOT always of the best quality; nor was much effort made to change styles to suit the European market. However, the Europeans liked these designs, which were seen as exotic. The shapes and decorations of Chinese Transitional wares had an effect on the kind of pieces the European potters made. They began to use tin-glazed earthenware to make copies of Chinese blue and white porcelain.

Height 7in/18cm Pair £D

Kangxi porcelain vases

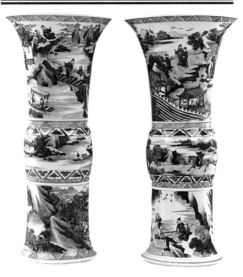

*B*ECAUSE OF THEIR SHAPE, THESE PIECES ARE
*known as beaker vases. The form of the vases was
derived from a Chinese bronze vessel called
a* gu, *which was an altar vase used to make
religious offerings. This pair was made during the
reign of Emperor Kangxi (1662–1722). In this
period, the wares were often made in the style of
older objects, indicating a taste for antiques.*

*I*N THE KANGXI PERIOD, PAINTING WAS WELL DEVELOPED
*and refined: designs were delineated, then filled in
with light or dark washes. These vases are
painted in a typical Chinese style, with figures in
landscapes divided by bands of geometric
decoration. This type of vase was often destined for
the West, where they were used for decorative
purposes; they were sold in pairs or in groups
of three, five or seven vases.*

Height 18in/46cm £E pair

Chinese exports

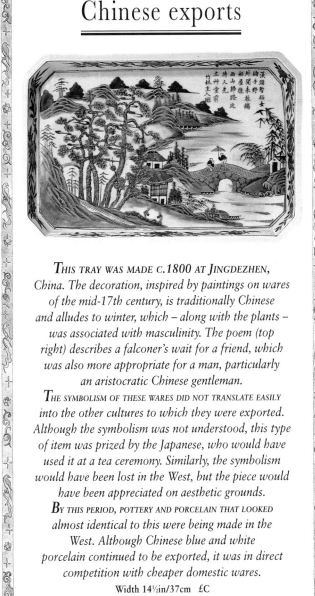

THIS TRAY WAS MADE C.1800 AT JINGDEZHEN,
China. The decoration, inspired by paintings on wares
of the mid-17th century, is traditionally Chinese
and alludes to winter, which – along with the plants –
was associated with masculinity. The poem (top
right) describes a falconer's wait for a friend, which
was also more appropriate for a man, particularly
an aristocratic Chinese gentleman.

THE SYMBOLISM OF THESE WARES DID NOT TRANSLATE EASILY
into the other cultures to which they were exported.
Although the symbolism was not understood, this type
of item was prized by the Japanese, who would have
used it at a tea ceremony. Similarly, the symbolism
would have been lost in the West, but the piece would
have been appreciated on aesthetic grounds.

BY THIS PERIOD, POTTERY AND PORCELAIN THAT LOOKED
almost identical to this were being made in the
West. Although Chinese blue and white
porcelain continued to be exported, it was in direct
competition with cheaper domestic wares.

Width 14½in/37cm £C

Arita porcelain flask

A LATE 17TH-CENTURY PIECE, *this flask was made at Arita, Japan. The Japanese had not been able to make porcelain until c.1600, when deposits of china clay were found there. But since then the Japanese had become proficient potters – it did not take them long to master the craft.*

*A*S THE MING DYNASTY *ended in China, the political situation became turbulent, and European merchants found it difficult to obtain blue and white porcelain from the Chinese. The Japanese were happy to fill the demand; they were already used to dealing with Dutch traders, who were given special trading privileges and operated out of their own settlement at Batavia in Java.*

*T*HIS FLASK IS DECORATED IN UNDERGLAZE BLUE. IT HAS *figures in landscapes, within geometric foliate borders, in the style of Chinese Transitional porcelain. The shape, however, is probably copied from a northern European stoneware flask. The Japanese sought to appeal to European markets by producing the shapes they wanted, painted with the Oriental decoration they had come to expect.*

Height 10¼in/26cm £C

Arita porcelain vase

ALTHOUGH THE TYPE of the vase and its decoration were inspired by Chinese blue and white porcelain, there are key elements that confirm this piece as Japanese. A large vase, it was made at the Arita kilns in Japan in the late 17th century. The decoration was applied with a variety of painting techniques, which were combined to create an overall effect.

THE PEONY AND CHRYSANTHEMUM FLOWERS IN THE CENTRE are Chinese in taste but painted in a non-Chinese way: the flowers and stems of the peonies give the impression that the artist had studied the plant – not what would be seen on an equivalent Chinese piece – and the leaves are spread out evenly across the surface to give a decorative effect. The contrasting bands of scrolls, called karakusa (octopus tendril), are highly stylized, and although derived from a Chinese source, they evolved into a Japanese form. The band of flower heads around the top of the vase is typical of Korean wares. By putting these styles together, the decorator produced a uniquely Japanese effect.

Height 23in/58.5cm £F

Arita porcelain drug jar

THIS RARE MID-17TH CENTURY DRUG JAR WAS made at Arita, Japan. It is unusual because although it is Japanese porcelain, decorated by a Japanese potter, it is a direct copy of a European object – an albarello, *or drug or pharmacist's jar.*

IN EUROPE, SIMILAR JARS (BUT MADE OF TIN-GLAZED earthenware) were used in apothecary's shops and hospitals; they were filled with medicines and herbs. The decoration is in underglaze blue, but a blank space has been left for a paper label giving the name of the herb or medicine in the jar.

NOT MUCH IS KNOWN ABOUT THE PRODUCTION OF the jars. However, shards of tin-glazed earthenware drug jars with similar decoration have been found in Java at Batavia, the Dutch trading settlement through which Japanese porcelain was exported to Europe. The jar may have been made for settlers in Java.

Height 10½in/26.5cm £F

Arita porcelain charger

THE INITIALS IN THE CENTRE OF THIS JAPANESE porcelain charger are those of the Dutch East India Company, which had the exclusive right to trade with the Japanese. VOC stands for Vereenigde Oostindische Compagnie. This dish was made at the Arita kilns in the late 17th century. There is some debate over why such dishes were made and who used them. Some seem to have stayed in Japan, although most of them were exported.

THE DECORATION IS NOT TYPICALLY JAPANESE BUT IS derived from the Chinese Wanli type of decoration, which was known as kraak *porcelain in the West (after the Portuguese merchant ships, which were called carracks). Radiating border panels were filled with paintings of flowers and birds. This type of dish was exported in great quantities to the West, so the Japanese potters were using a style that they could sell easily in Europe.*

Diameter 14½in/37cm £D

Florentine maiolica jars

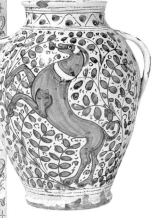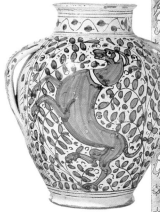

THESE JARS WERE MADE C.1480 IN FLORENCE,
an important early centre of Italian pottery
production. They are made of tin-glazed
earthenware, called maiolica *in Italy; early imports*
came from Spain via Mallorca, hence the name.
ITALIAN POTTERS BEGAN MAKING TIN-GLAZED EARTHENWARE
in the early 13th century. The thick white lead glaze,
with oxide of tin added to it, has the white quality
associated with Chinese porcelain. With the
exception of the blue and white palette, however,
there is little Chinese influence in the decoration.
The animals and scrolling foliage are derived
from Gothic art and heraldry, a style used since
Florentine pottery production began.

THE JARS WERE USED TO STORE HERBS AND MEDICINES
at pharmacies and hospitals, which were often
adjoined to monasteries. Potteries nearby supplied
the jars, which were decorated with heraldic
or religious emblems appropriate to the institution.
Height 10¼in/26cm £E

Medici porcelain flask

A SOFT-PASTE PORCELAIN, ALSO *known as artificial porcelain, was used to make this flask in Florence c.1573–87. It is among the first porcelain items ever to be manufactured in Europe. In this instance, the flask was made from an amalgam of white clay, sand, crushed quartz, glass and oxides of lead and tin, giving it the white, translucent qualities of hard-paste, or real, porcelain.*

*T*HE FLASK WAS MADE AT A FACTORY ESTABLISHED BY THE *Grand Duke Francesco I de Medici. His intention was to produce porcelain in Italy that would rival Chinese porcelain. This gave the Duke prestige. Making this experimental porcelain was expensive, however, and production was limited. When it ceased, the secret of making the porcelain died too. Only about 75 pieces are known to exist, making it some of the rarest porcelain in the world.*

*W*HILE THE SHAPES OF MEDICI PORCELAIN ARE OF *European inspiration, the decoration, in underglaze cobalt blue, is often based on the type found on Chinese porcelain. The decoration on this particular flask, however, is European in style.*

Height 7½in/19cm £G

Faenza maiolica crespina

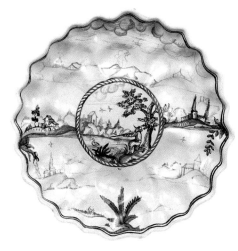

*THIS CRESPINA (THE NAME REFERS TO ITS
gadrooned shape) was made at the Italian town of
Faenza, c.1650. Faenza began to make tin-glazed
earthenwares in the late 14th century, and by the end
of the 15th century it was one of the foremost
producers. Its reputation was such that it gave its
name to "faience", meaning pottery.*

*FAENZA MADE A WIDE RANGE OF MAIOLICA, DECORATED
in every style imaginable. As a result, wares from
Faenza can be hard to identify. Much of its production
consisted of plain wares resembling porcelain,
whose beauty lies in their simple shape. Sometimes
these were simply decorated, with sketchy
architectural elements, swags and cupids painted in
blue with touches of yellow. This style is known as
compendiario, which means shorthand. This dish
is too modern in character to belong to the style, but
the painting retains some of its qualities.*

Diameter 12in/30cm £C

Savona maiolica bowl

THE SHAPE OF THIS GADROONED BOWL, MADE c.1700 at Savona in Italy, derives from that of silver dishes. Gadrooning was popular in this area; even when wares were of plain shape, they were painted with arches to give the impression of gadroons.

FROM THE 17TH CENTURY, MAINLY BLUE AND WHITE MAIOLICA was made at Savona. This was due to the influence of Chinese porcelain, which Dutch merchants first brought to Genoa in 1606. The Chinese influence is easier to see in early pieces, but the interpretations of Chinese designs were loose, giving the maiolica a particular quality. As the Italian style developed, more European elements were introduced until, eventually, it became a style all of its own, known as calligrafico naturalistico.

Diameter 22in/56cm £D

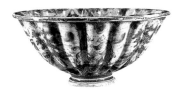

Meissen porcelain tray

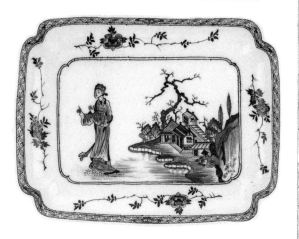

THE MEISSEN PORCELAIN FACTORY, NEAR
Dresden, produced this tray c.1730. The factory
was under the patronage of Augustus I, the elector
of Saxony and king of Poland. His interest in
discovering a "philosopher's stone", to turn base
metals into gold, led him to employ alchemists.
Instead, they discovered how to make true
hard-paste porcelain from local china clay in 1708.
AT FIRST, DECORATION WAS OFTEN ONLY RELIEF MOULDING
or simple gilding: the ware was deemed to be
beautiful in its own right. But Augustus, who desired
blue and white porcelain like the great Chinese
pieces in his palaces, was disappointed. It
was only c.1721 that the factory successfully
fired cobalt, from local deposits, at a temperature
which did not cause it to discolour. Designs in
blue were either copies of Chinese designs or
interpretations of Chinese designs – like the one
on this tray, which is properly called chinoiserie.
Width 11½in/29cm £D

Meissen porcelain teapot

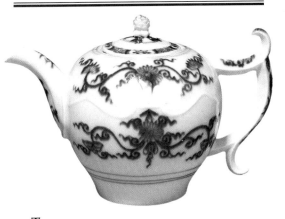

THE DESIGN FOR THIS SMALL TEAPOT, MADE AT
the Meissen factory in Saxony c.1745, is influenced
by those made of silver and Chinese porcelain.
The porcelain, the moulding and the glaze
are all of high quality, something that Meissen
achieved early on – without seeking outside
help to develop the technology. This teapot is
as good as or better than the Chinese equivalent
or any other made in Europe at the time.

MEISSEN DECIDED THAT WARES PRODUCED AT THE
factory should be marked. The earliest mark was
an "AR" monogram, for Augustus Rex, the elector
of Saxony and king of Poland. Other marks, such
as "KPM", "KPF" and "MPM" also exist, as
well as symbols. By marking their wares,
often in underglaze blue, Meissen was declaring
that it could be judged on its merits alone.

Height 4in/10cm £D

The most famous mark
was crossed swords,
taken from the Saxon
coat-of-arms, which was
used from 1724.

Meissen porcelain tureen

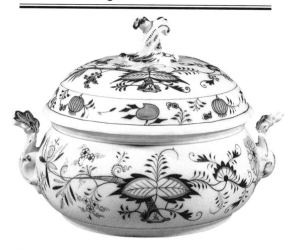

WITH A SHAPE INSPIRED BY THE EARLY 18TH-CENTURY *baroque period, this tureen was made at the Meissen factory, c.1900. The decoration is loosely derived from porcelain from the Far East. The "Zweiblemuster" ("Onion") pattern is an arrangement of stylized flowers and has been used by Meissen since the 1730s. The pattern and variations of it, made by different factories, are still in production and are familiar throughout Europe.*

DATING PIECES CAN BE DIFFICULT WHEN THEY HAVE BEEN *in continuous production with little change. Careful examination of a piece, however, will reveal some clues. Unevenly painted cobalt suggests the 18th century; on this later example, the lines are evenly drawn. The Meissen mark, crossed swords, is smaller on earlier pieces than on later ones. Meissen also used impressed numbers: 18th-century pieces have two-figure numbers; later pieces use three or more figures.*

Width 12½in/31.5cm £A

Venice porcelain teabowl

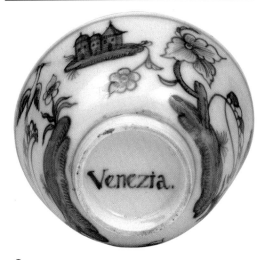

In the 16th century, some early experiments to make porcelain were done in Venice; it was there, at the Vezzi factory, that this tea bowl was made, c.1725. The Vezzi were a wealthy family and invested in a porcelain factory. Having gained the expertise of an arcanist from Meissen – the arcanists were a select group to whom the secret of porcelain making was entrusted – they negotiated to use the same china clay used to make Meissen porcelain. It was imported to Venice under a special arrangement, the only one in Europe.

The Vezzi factory made good-quality porcelain, inspired by Chinese porcelain, yet retaining an element of European style. Some were delicate pieces, such as this tea bowl. Others were bold, with some of the most original designs of any European factory. Wares made between 1725 and 1740 are marked with a V or in full, as here.

Diameter 2¾in/7cm £D

Frankfurt fayence dish

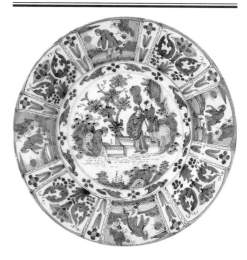

THE GERMAN WORD FOR FAIENCE IS "FAYENCE" and, along with delft and Dutch Delft, these are all tin-glazed earthenwares. This dish was made c.1700 and, for a long time, it was thought that such dishes were made in Frankfurt. Now some believe that they were made in Delft in Holland, but not with the usual decoration. This design does appear on wares from Holland; it also appears on those made in London, illustrating the difficulty in attributing a piece's origins by style alone.

THE MAKING OF TIN-GLAZED EARTHENWARE BEGAN IN Germany in the mid-16th century, and after the importation of Chinese Wanli porcelain in the 17th century, native potters began copying the designs. This dish is one example, but it does not follow the original slavishly: the flowers are European in style and there are also touches of darker manganese oxide, in addition to cobalt.

Diameter 15¾in/40cm £C

German fayence shoes

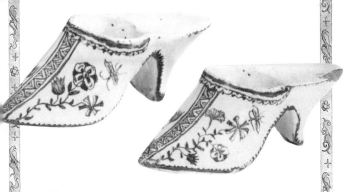

FROM THE MIDDLE AGES, GERMAN POTTERS MADE
stonewares which were exported all over Europe.
Lead-glazed earthenwares, or Hafner wares, were
used locally. When the technique of making tin-glazed
pottery reached Germany in the mid-16th century,
it was the Hafner potters who took it up. By the 18th
century, these potters were facing strong competition
from imported Chinese porcelain, a more
durable and pleasing product. There was also some
competition from other European porcelain.

TO PLEASE THEIR CUSTOMERS, THE TIN-GLAZE POTTERS
worked hard to produce good-quality wares that
appealed to contemporary fashions and tastes.
Many amusing shapes and objects were made,
including these mid-18th century shoes. While the
most fashionable shapes were usually produced
by the important factories, such as Meissen,
ordinary potters were quick to copy their novel
ideas. The tin-glaze potters, however, excelled in
painting and decorating skills; they developed
techniques for decorating in enamels on tin glaze,
which the porcelain factories adopted.

Length 4¾in/12cm £C

Turin maiolica centrepiece

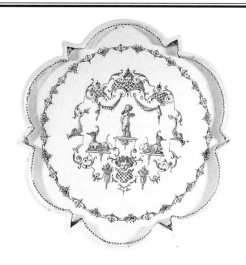

A TRAY WITH FOUR FEET, THIS CENTREPIECE WOULD have stood on a table, perhaps filled with fruit. It was made c.1730 in Turin, Italy, possibly at the factory run by the Rosetti family. The shape, known as altazza *in Italian, is derived from silver originals. The tray is not typical of what other Italian factories were making at the time. The decoration looks more like the type seen on French porcelain or faience; in fact, the northern Italians were influenced by French taste, and Turin is near Moustiers, which made blue and white faience much like this in style.*

THE DECORATION WAS INSPIRED BY THE CLASSICAL ornaments favoured in France in the mid-16th century. In the 17th century, Louis XIV's architect Jean Berain perfected these delicate architecturally inspired designs, hung with swags and scrolls and encircled by borders. The designs are always symmetrical and controlled.

Diameter 15½in/39.5cm £C

Dutch Delft bowl

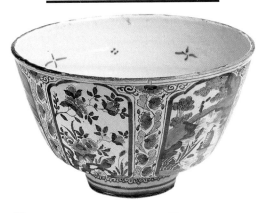

*THIS BOWL WAS MADE IN DELFT, HOLLAND, IN THE
early 18th century. It is a copy of a Chinese blue
and white original made during the reign of Emperor
Wanli, when this type of decoration of birds and
flowers in radiating panels was popular.*

*TIN-GLAZED EARTHENWARE WAS MADE AT DELFT IN HOLLAND
in 1584. When Chinese porcelains began to arrive in
the early 1600s, they caused a stylistic revolution.
Coloured wares were given less prominence, and the
bulk of production turned to blue and white. By 1675,
Delft was the most important centre in Europe
producing tin-glazed earthenwares; indeed, its name
has become synonymous with the type of ware,
and the term "Dutch Delft" is used to distinguish it
from delft produced in other countries.*

*TRADE FLOURISHED, WHICH MUST HAVE BEEN DUE IN PART
to the good quality of the wares. Dutch merchant
ships sailing abroad left Holland with their holds filled
with pottery. All sorts of wares were made,
from simple, useful tiles and dishes to elaborate,
architectural pieces, such as tulipières.*

Diameter 13¼in/35cm £B

Dutch Delft vase

THIS TIN-GLAZED EARTHENWARE vase was made at Delft, Holland, in the early 18th century. It is part of a set of large vases, of which there were probably five, which would have been displayed in a formal arrangement, perhaps on wall brackets. Vases were sold in pairs or in sets of three, five or more. As "Chinamania" – the passion for blue and white porcelain – took hold of Europe in the 17th century, monarchs set aside whole rooms and palaces to display their collections of Oriental porcelain. As European pottery and porcelain improved in quality, it was displayed alongside Oriental pieces.

ALTHOUGH ORIENTAL IN SHAPE, THIS VASE IS DECORATED IN a style that blends European and Chinese designs. It can be difficult to tell where a piece was made; tin-glazed earthenwares made in Holland are similar to those from Germany, France and Great Britain. However, Dutch wares are often marked.

Height 19in/48cm £C

This vase is marked in a way not seen on delft from other countries, confirming it as Dutch.

Dutch Delft plates

*The decoration of figures in rural landscapes,
usually fishing or tending their livestock, as on
these early 18th-century plates, is typically Dutch.
The Dutch were among the first potters to use
ordinary people and situations as subject matter,
and by applying the style to their wares, they have
made it famous worldwide. This representation
of everyday subjects in art springs from a long
tradition of self-reliance. The Netherlanders were
prosperous; they made their money by working,
whether at trades or agriculture or as
merchants, and it was deemed fitting to represent
this way of life in the art of the country.
When these plates were made in Delft, the pottery
industry had already had its heyday. The factories
continued to make tin-glazed pottery, either in
traditional Dutch styles or copying Chinese porcelain,
but they did not progress. Because of competition
from British creamware (a better earthenware),
Dutch Delft declined in the late 18th century, and it
had to be revived in the 19th century.*

Diameter 9in/23cm £C each

Southwark delft bottle

THIS TIN-GLAZED DELFT bottle was made in London at Southwark in 1628 (the date is inscribed just below the handle). The shape of the bottle is inspired by German stoneware wine flasks, which were exported worldwide. The birds in flight over flowers and plants are inspired by blue and white Chinese Ming porcelain.

TIN-GLAZED WARES WERE probably first made in England in the mid-16th century by potters from the Low Countries, who settled in England. The production was sophisticated; the potted clay vessel (moulded or thrown) was fired at a low temperature before being dipped in tin glaze. The clay body absorbed the water content of the glaze, leaving a dry surface that could be painted on. The potters then decorated the wares in colours which would withstand the second, higher temperature firing; cobalt blue was one of the more stable colours. The earliest English tin-glazed wares were made in London and were mostly coloured, in the style of Italian maiolica. In the early 17th century, however, potters in Southwark began making blue and white Chinese-inspired wares.

Height 7¼in/18.5cm £F

London barber's bowl

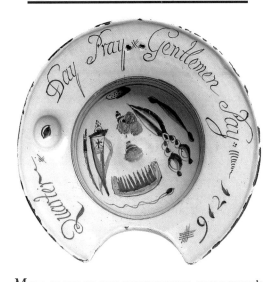

Made of tin-glazed earthenware, this barber's bowl was made in London in 1716. It is dated on the rim beside the inscription, which reads "Quarter Day Pray Gentlemen Pay". This refers to the fact that some customers paid quarterly. The depression in the rim of the bowl was probably to hold soap. While the barber shaved the customer, the bowl, filled with hot water, was held under the customer's chin, with the hollow in the rim against his neck. When not in use, the bowl was hung up, probably on a cord laced through the two holes.

These bowls exist in Chinese and Japanese porcelain, and were made all over Europe. This example, however, has an English characteristic: the tin glaze is blue-tinted with cobalt. The bowls changed little between the late 17th and late 18th centuries and are hard to date when not inscribed.

Diameter 10¼in/26cm £F

London delft plaque

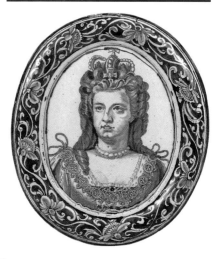

Plaques such as this were displayed either hung on a wall or built into the exterior wall of a building. Probably made in London, c.1705, this plaque has a portrait of Queen Anne, based on a portrait by J.B. Clostermann. Printed engravings of the portrait were in circulation at the time. The piece is a good example of the high quality of work achieved by English delftware potters.

Painting on tin glaze requires considerable skill. The painter has to work quickly, since the cobalt pigment sinks in at once, making it difficult to alter mistakes. It is possible to "pounce" a complicated design, such as this one, on to the surface. The design is traced on to paper and holes are pricked through it following the tracing. The paper is then placed on the piece and a coloured dust is sprinkled on. After removing the paper, the painter can follow the outline left behind.

Height 9in/23cm £E

English delft tankard

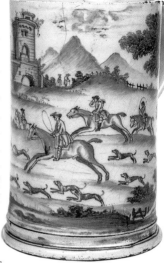

Intended for ale, this tin-glazed tankard was made in 1766 – it is inscribed with the date on the base – probably in London. Genuinely dated examples of pottery are important to ceramics historians, since sometimes little is known about how and where potters worked and about their wares.

This tankard is genuinely of the late 18th century: the dress of the riders, the way the horses are painted, with front and back legs simultaneously extended, and the landscape scattered with ruined buildings are all right for the period. Stoneware tankards of a similar shape and decorated with hunting scenes were made in London, particularly at Vauxhall, where there is known to have been a delft factory.

At this time, English delft potteries were on the brink of a decline, from which the industry never recovered. English blue and white delft was the most common crockery in the first half of the 18th century; there were one or more potteries in every principal town. But by the early 19th century, these had nearly all disappeared. Easily chipped delftware was replaced by creamware – cream-coloured earthenware – a durable pottery.

Height 8in/20cm £E

Dublin delft basket

A FACTORY OWNED BY CAPTAIN HENRY DELAMAIN,
*an Irishman of French extraction, produced this
tin-glazed basket in Dublin, c.1755. He bought the
delft works in 1752, and production under his
ownership lasted until his death in 1757, although
the factory continued until 1771.*

*D*ELAMAIN SPENT HIS ENTIRE FORTUNE TO BUILD NEW
*works for the factory. His aim was to stem the tide
of imported earthenwares flowing into Ireland
and to prove that the same, if not better, quality
wares could be made by Irishmen. He even exported
wares to help the Irish trade balance.*

*T*HIS BASKET IS AN EXAMPLE OF THE GOOD-QUALITY
*wares he produced. The sides are delicately cut
out, which is technically difficult to do, and the
landscape is exquisite, unlike anything seen
on other delftwares. But due to lack of funds, the
business folded, and Delamain's dream of a strong
Irish pottery industry was never realized.*

Diameter 6½in/16.5cm £D

British delft charger

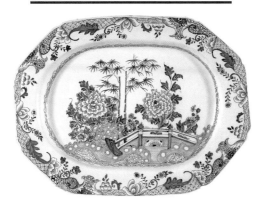

THE MAKING OF DELFTWARE IN LIVERPOOL BEGAN only in 1710, but by 1760 there were 12 delftware potteries. There was a considerable exchange of raw materials, craftsmen and ideas with the Irish industry, so Liverpool and Irish delftwares look similar and are difficult to tell apart.

THIS TIN-GLAZED EARTHENWARE CHARGER WAS MADE c.1750. It is certainly British delftware – the glaze has a slight blue tone from the addition of cobalt. It was probably made in Liverpool or Ireland, but the exact location is unknown.

THE STRONGEST STYLISTIC INFLUENCE ON THE PIECE IS that of Chinese porcelain, which was imported in quantity in the mid-18th century. Although porcelain was made in Great Britain at the time, it was a rarity; Chinese wares competed with delftware.

Width 22¼in/56.5cm £C

The decoration, in particular the elaborate scroll borders, is rococo in style, establishing the date as mid-18th century.

Scratch blue loving cup

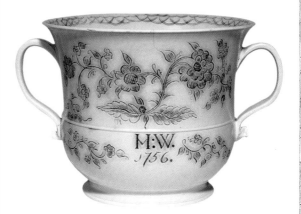

A STONEWARE PIECE WITH A SALT GLAZE, *THIS*
two-handled cup was made in Staffordshire. It is
incised with the initials of the person it was made
for and the date 1756. Cups like this are sometimes
called loving cups; it is thought that they were
intended for communal drinking, the two handles
making it easy to pass from person to person.
*T*HE CUP IS TYPICAL OF THE WARE MADE IN *S*TAFFORDSHIRE
in the 18th century. Potters used the same clay that
was used to make creamware (see opposite)
but it had to be fired at a higher temperature. This
clay could be finely and thinly potted, which
the potters sometimes did to imitate porcelain.
While the cup is inspired by Chinese blue and
white porcelain, it is decorated using the scratch
blue technique: the design is incised into the body
and cobalt rubbed into the incisions. This creates
a deeper blue colour when combined with
a salt glaze. Salt-glazed stoneware ceased to
be made in Staffordshire in the 1780s.

Width 12in/30cm £E

Creamware teapot

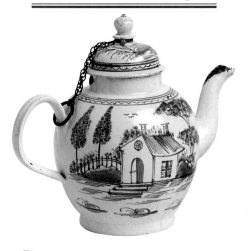

*D*ECORATED WITH UNDERGLAZE BLUE, THIS
*teapot is made of creamware (at first called cream-
coloured earthenware). The front displays a
landscape scene. The reverse is painted with the
name of the lady who owned it, along with a picture
of her taking tea, and the date 1781. The teapot was
probably made in Staffordshire, where creamware
was first made in the 18th century.*

*F*ROM THE MIDDLE AGES, POTTERS HAD BEEN MAKING
*earthenwares, with white clays and slips as
decoration. They found that calcined flints added to
white clay could be finely potted and painted with a
lead glaze. The clay was of good quality and
a colour close to the "white" associated with
porcelain. It was the most popular ware in Great
Britain from c.1760 to 1820. Josiah Wedgwood
refined the material and made it in fashionable
shapes. He was so successful that Queen Charlotte
ordered a tea set, starting a new trend.*

Height 5in/13cm £C

Marseilles faience dish

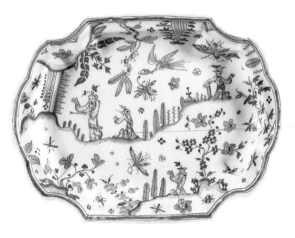

THE LEROY FAMILY MADE THIS DISH C.1760 IN
*Marseilles, France. The making of tin-glazed
earthenware, or faience, was brought to France by
Italian workers. Potters from the two countries had
exchanged ideas before – in the mid-16th century,*
istoriato *maiolica dishes similar to the Italian originals
were made at Rouen, Lyons and Nevers.*

IN THE 17TH CENTURY A NATIVE FRENCH STYLE EMERGED
*from Rouen, derived from the designs of the architect
Jean Berain. Faience, and porcelain, was decorated
in blue with delicate, fantastical architectural
decoration within borders of scrolls and lambrequins.
This style was the most typical, and elegant,
decoration on French faience. To a lesser extent,
Chinese blue and white porcelain was copied, as well
as Dutch Delft. Chinoiseries became popular
in the late 18th century, when French faience reached
its height. This tray has exaggerated chinoiserie
decoration, giving it a fanciful touch.*

Width 14¼in/36.5cm £C

Scandinavian faience tray

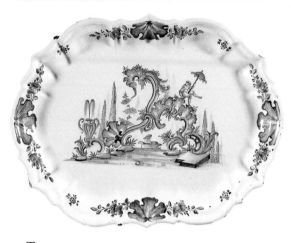

*THIS ELEGANT MID-18TH CENTURY TRAY WAS MADE
in northern Europe or Scandinavia, perhaps by a
factory in Schleswig-Holstein. A factory was
established in Schleswig c.1750 by German migrants,
and it played a key role in the growth of the faience
industry in Germany, the Baltic and Scandinavia.
Schleswig was in Denmark at the time, and there
were restrictions on making blue and white faience to
reduce competition with blue and white porcelain
from Copenhagen. So the factory painted its wares in
manganese on a white or coloured background,
and painted flowers in enamels, a skill which had been
perfected in Germany and France.*

*THE SHAPES OF LATE 18TH-CENTURY SCANDINAVIAN WARES
were often extravagant. The style is reflected in the
decoration on this tray, where Chinese-style rocks
are combined with rococo scrolls, on which a small
figure perches. The ornaments are well painted,
but the figure painting is often poor.*

Width 15in/38cm £C

French porcelain knife

THE HANDLE OF THE KNIFE
is French porcelain, and it was
probably made in the early
18th century. The material used
is an artificial, or soft-paste,
porcelain – the soft lead glaze
can be scratched with a steel
blade. The design of scrolls and
lambrequins is typically French.

THE FRENCH BECAME FAMILIAR WITH
porcelain through Chinese and
Japanese imports, but at first they
did not have the technology or
materials to make it themselves.
China clay, used in true porcelain,
was discovered in the late 18th
century near Limoges, where most
French porcelain is made today.

VARIOUS ACCOUNTS ARE GIVEN OF
how experiments by French
faience makers led to the
production of porcelain. It was
first made by Louis Potterat in
Rouen, who kept its manufacture
a secret. The next makers were
the Chicaneau family, who ran
the St. Cloud factory owned
by the Duke of Orléans, brother
of the king. They failed to keep
the porcelain recipe a secret,
and the Mennecy, Vincennes
and Sèvres factories developed
in the 18th century.

Length 4in/10cm £B

Chelsea porcelain saucer

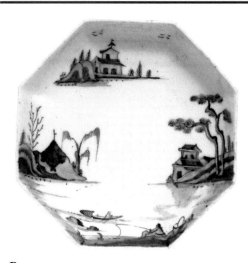

PAINTED IN UNDERGLAZE BLUE, THIS SAUCER WAS
made at the Chelsea factory in London in 1753.
Porcelain manufacture came to London with the
exodus from France of the Huguenots, some of whom
set up a factory at Chelsea, c.1745. The early years
of the factory are not well documented.
AN ARTIFICIAL, OR SOFT-PASTE, PORCELAIN WAS USED,
the recipe for which was derived from French
porcelain. Early pieces were rococo in style, often
based on natural forms or silver shapes. Some were
inspired by Chinese or Japanese shapes, like this
example. Not much Chelsea porcelain was decorated
in underglaze blue; in fact, underglaze blue wares
in general are rare – only five saucers such as
this one are thought to exist. Most Chelsea porcelain
was decorated in colours with flower sprays in
the Meissen style, in Japanese Kakiemon-style
colours or in a Sèvres-inspired rococo style.

Width 4¼in/11cm £D

Bow porcelain inkwell

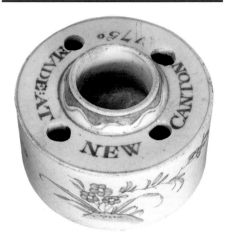

THE BOW FACTORY, THE FIRST PURPOSE-BUILT porcelain factory in England, made this inkwell in 1750. The inscription, "Made at New Canton", refers to the name given to the factory. It was established to compete with Chinese porcelain imports, and by calling itself New Canton, it was asserting that its porcelain was as good as that made in China. The works started making soft-paste porcelain c.1750 and aimed its wares at the middle classes. Bow discovered that adding bone ash to their porcelain gave it increased strength. This made it perfect for tea wares, a fact their advertisements emphasized. Essentially, this was the invention of English bone china.

BOW MADE BOTH FIGURES AND USEFUL WARES. THE USEFUL wares were often decorated in blue but seldom marked. The factory sometimes copied the wares of other factories, along with their marks, but these are easy to distinguish from the originals.

Diameter 3½in/9cm £E

Bristol porcelain mug

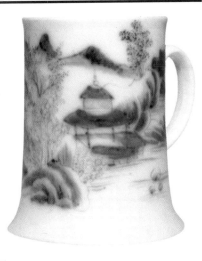

*T*HIS MUG WAS MADE C.*1750* AT THE FIRST *porcelain factory established in Bristol. It was owned by Benjamin Lund, but it did not last long – from 1750 to 1752 – and its wares are rare. Bristol had been a centre for ceramics since the Middle Ages, when earthenwares were made there, and in the 17th and 18th centuries, tin-glazed earthenwares (delft) were made in the city.*

*T*HE FACTORY USED SOAP ROCK FROM CORNWALL TO *make their porcelain. This was incorrectly believed to be the same mineral used by the Chinese to make their wares, but it made perfectly good porcelain, with a green-blue hue. Most of the pieces were of Chinese inspiration, and some were marked "Bristoll". When the Worcester porcelain factory bought the works, any marked pieces decorated at Worcester had their marks disguised with painted decoration.*

Height 4¾in/12cm £D

Worcester sauce boats

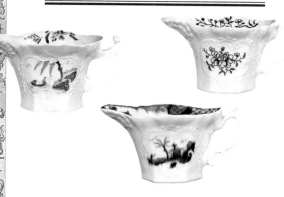

A FACTORY IN WORCESTER IS RESPONSIBLE
*for making these cream boats. The first was made
c.1758, the second and third c.1765. The factory,
in which Dr. John Wall was the principal
shareholder, was founded in 1751. It is thought that
it was originally founded to acquire
the rights to the Cornish soap rock owned by
the Bristol porcelain company; in 1752, the
Worcester company bought out the Bristol factory.
The early patterns may have been painted by
delft painters from Bristol.*

*T*HE NAME OF THE EARLY FACTORY, THE "WORCESTER
*Tonquin Manufacture", declared its intention to
compete with Chinese porcelain. It became one of the
most prosperous English porcelain factories,
building its success on its blue and white wares, which
made up over 70 percent of its output.*

Width 4½in/11.5cm £C each

The left boat has a pseudo-
Chinese character as a work-
man's mark. A crescent used
as a factory mark was painted
(centre) or printed (right).

Worcester spoons

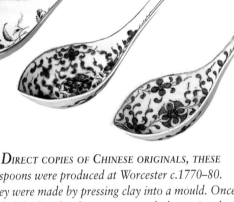

DIRECT COPIES OF **C**HINESE ORIGINALS, THESE
spoons were produced at Worcester c.1770–80.
They were made by pressing clay into a mould. Once
slightly dry, the clay was removed, then painted,
glazed and fired. In China, the spoons were used
for soup. In England, however, they were used as
caddy spoons; the pierced one (centre) was probably
used for scattering sugar on fruit.

WHILE THESE EXAMPLES ARE DECORATED WITH PAINTED
designs, some were transfer printed. Transfer
printing at Worcester started c.1756, when most of
the prints used were black. Prints in blue began
c.1758; this made the production of blue and
white wares even easier. The kind of porcelain made
by Worcester withstood hot water well, making it
suitable for tea wares; it could also be mass-
produced. Worcester probably produced more
porcelain than any other factory in Great Britain
at the time. There is still a direct descendant of
the orginal factory at Worcester today.

Length 5½in/14cm £B each

Caughley asparagus server

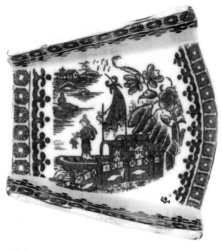

THIS UNUSUAL FAN-SHAPED OBJECT IS AN asparagus server – it was designed to hold individual servings of asparagus tips. The servers were sold in sets. This one was made at the Caughley factory in Shropshire c.1780.

THE CAUGHLEY FACTORY BEGAN IN 1750 AND WAS TAKEN over in 1772 by Thomas Turner, who had trained at the Worcester factory. The porcelain made at Caughley imitated Worcester wares. This pattern, which is transfer printed in underglaze blue, is now known as the "Fisherman" or "Fisherman and Cormorant" pattern. At Worcester, it was originally called the "Pleasure Boat" pattern. The Caughley pattern is similar to the Worcester one, but there are variations; usually, the fish held by the man in the foreground is thin on Worcester porcelain and fat on Caughley porcelain. It is one of the most common patterns on late 18th-century English porcelain.

Length 3in/7.5cm £A

Lowestoft porcelain jug

THIS JUG WAS made c.1765 at the Lowestoft factory in Suffolk. It was decorated in two ways: with moulding and with painting in underglaze blue – a combination also used by Chinese potters. Although the particular design on the jug was not used by the Chinese, this piece catches the spirit of their style – it is the shape of the jug that makes it truly English. The jug is painted, but Lowestoft also printed on wares.

THE LOWESTOFT FACTORY WAS IN DIRECT COMPETITION WITH the Worcester factory, often copying its patterns and shapes. This jug is in the style of a Worcester jug, but it is not an exact copy. It is easy to distinguish between porcelains from the two factories. Lowestoft porcelain is not as well made; for example, this jug was misfired, giving it a speckled appearance. Lowestoft did use a crescent mark, copying Worcester, but they often used other marks.

Height 9in/23cm £C

The jug is marked with the number 2, which is a decorator's mark. These were often found on Lowestoft porcelain.

Lowestoft tea canister

THE LOWESTOFT FACTORY, WHICH produced wares from 1757 to 1802, made this tea canister c.1765. The Lowestoft works copied the chinoiserie style of Worcester, but its porcelain contained bone ash, which gave it added strength. The factory made tea wares and other useful wares, and much of its output was blue and white. It was mostly unpretentious porcelain aimed at the middle classes.

THE TEA CANISTER WOULD HAVE FITTED INSIDE A WOODEN box, or tea caddy, that could be locked. Tea was expensive in the 18th century and reserved for the privileged, which is why it was kept under lock and key. The canister is inscribed "Singlo Tea", probably a type of Chinese tea. Inscriptions on Lowestoft porcelain are not unusual; sometimes they consist of the names of people who worked at the factory. This tea canister is rare as it has survived with its lid intact, and it may be the only piece of its type to have done so. The lid is decorated with a water fowl and reeds; floral designs appear on the top of the body.

Height 5in/13cm £D

Pagoda pattern

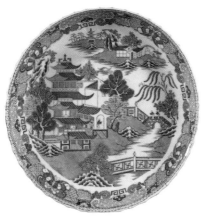

*THIS DISH WAS MADE AT MILES MASON'S FACTORY
in Staffordshire, c.1805. At first glance, the print
may be mistaken for the "Willow" pattern, which
was erroneously thought to tell the story of a young
man and woman in love, separated by a cruel
father. The dish actually bears the "Pagoda", or
"Broseley Willow", pattern. The "Pagoda" pattern,
once as popular as the "Willow" pattern, was first
printed at the Caughley factory, c.1780.*

*THESE PATTERNS WERE INTENDED TO REPLACE CHINESE
porcelain, when import duties were increased in
1792–96 to keep it out of the market. Factories
such as Mason's were able to fill the void
with good-quality porcelain decorated with line-
engraved transfer prints, such as this one.*

Diameter 7½in/19cm £A

A pseudo-Chinese
character appears as a
mark on the base of some
porcelain wares from
Miles Mason's factory.

Chinoiserie patterns I

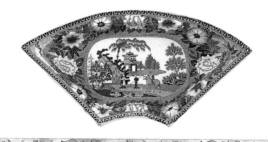

EARLY EXAMPLES OF chinoiserie patterns can be seen on the plate (left) and the dish (below). In the first half of the 19th century, such patterns were transfer printed in underglaze blue on earthenware pottery in Staffordshire.

FIGURES IN A LANDSCAPE WITH pavilions are printed on this plate, made c.1820. The pattern is close to the Chinese originals, using the correct type of border, but it was designed in Staffordshire rather than in China.

THE FAN-SHAPED DISH IS PART OF A SUPPER SET. A NUMBER of covered dishes were fitted together in a circle set in a tray. This dish is printed with the "Zebra" pattern, of which there are two variations. This one was possibly made by Toft & May, who probably copied the pattern from the Rogers factory. The pattern is a combination of Oriental-inspired designs, with a zebra for added exoticism, and a European-style floral border. It is not unusual to see a combination of styles on wares of this period.

Width fan-shaped dish 13in/33cm £A

Chinoiserie patterns II

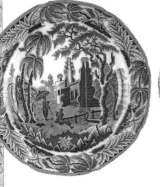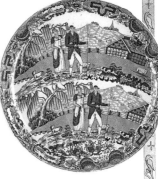

THE PLATE (LEFT) AND DISH (RIGHT) WERE TRANSFER printed in underglaze blue, with chinoiserie patterns from a transitional period in the early 19th century. There were hundreds of factories operating in Great Britain, most of them in Staffordshire, making pottery for export. The wares were of good quality and designed to be novel and appealing. They were mass-produced, however, and aesthetic appeal sometimes took second place.

FIRST PRODUCED C.1810, THE "CHINOISERIE RUINS" pattern on the plate was taken up by several potteries. The pattern appealed to the European interest in the picturesque by having a ruin as the focal point; the Chinese details emphasize the Oriental nature of the subject.

THIS DISH, MADE C.1810 AT THE SWINTON (LATER Rockingham) Pottery in Yorkshire, is printed with a variation of the "Shepherd" pattern – a European couple in a Chinese-style landscape and border. The transfer print is repeated twice, but the lower one has been torn to fit the space.

Diameter 8¼in/21cm £A each

Chinoiserie patterns III

*As the 19th century
progressed, British
potteries continued
to use Chinese-
inspired designs
to decorate their
wares. But as
aesthetic tastes
changed with the
advancing century,
the approach to
decoration altered.
One example is this
1820–30 earthenware plate,
with a transfer print in underglaze blue. The maker
and the pattern remain unidentified.*

*Earlier British Chinoiserie designs on ceramics
were linear. This was because of the style of
engraving used on the copper plates from which the
transfer prints were made; lines were straightforward
and shading was done by hatching. From the early to
mid-19th century a taste developed in the decorative
arts for a three-dimensional effect, whether in
furniture, textiles or ceramics. Engravers began using
stipple engraving to achieve subtle shaded effects
and attention was paid to perspective.*

*The plate shows a Chinese scene, but in perspective.
The flowers in the Chinese-style border have
a three-dimensional appearance rather than the flat
stylization they once would have had. In addition,
between 1830 and 1860 the blue used on
transfer-printed designs became progressively
lighter, as shown on this example.*

Diameter 10¼in/26cm £A

European scenery patterns

"MONASTERY AT TRE Castagne" is the title of this scene, from the series "Named Italian Views". It was printed in underglaze blue at the Don Pottery, which operated in Swinton, Yorkshire, from 1834 to 1893.

THE SCENES THAT MADE UP this series were all originally drawn in Sicily and southern mainland Italy. They were probably engraved individually, collected and published in a sketchbook. Because there was no copyright law at the time, the potters were not restricted from copying directly from such a source and did not hesitate to do so.

POTTERY PRINTED WITH SCENIC VIEWS SUCH AS THIS was popular between 1830 and 1860; the plate, with its heavy floral border typical of the mid-19th century style, was probably made before 1850. In the 18th century it was fashionable for the aristocracy to travel in Europe. As the middle classes became more prosperous in the 19th century, they began to travel, too. Their destinations were often Italy and Germany, which were seen as suitable because of their long traditions of art and culture, their beautiful scenery and their romantic associations – notions that are mirrored in the printed patterns.

Diameter 8¼in/21cm £A

Hunting patterns

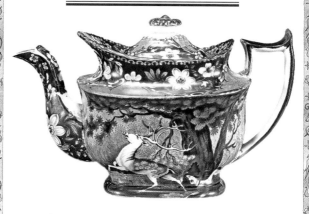

A PATTERN OF A STAG HUNT DECORATES THIS
*earthenware teapot. It was made in England, perhaps
in Staffordshire, c.1820. Hunting was a popular
subject in the arts in the early 19th century, partly
because of romantic associations.*

*T*HE WORDS "STONE CHINA" IN A LOZENGE ARE PRINTED
*on the teapot's base; they were used as a trademark
by at least 16 makers in Staffordshire. In 1813,
the C. & G. Mason factory registered a patent for
"Mason's Patent Ironstone China", which was a
successful earthenware made at their factory at Lane
Delph, Staffordshire. Every piece carried a printed or
impressed mark to declare its origin. Other potters
wishing to emulate their success printed such terms
as "Stone China" or "Ironstone" on their wares.*

*I*T IS DIFFICULT TO IDENTIFY WHO MADE THE TEAPOT
*by looking at the mark. Similarly, the pattern is not
necessarily a clue to the origin, although some are
identifiable. But the mark and the shape of the
teapot – which was fashionable only briefly in the
early 19th century – date it at c.1820.*

Width 9½in/24cm £B

Naturalist patterns

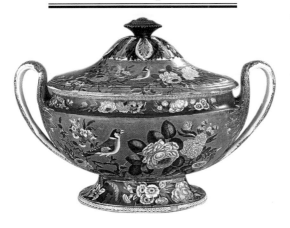

THIS EARTHENWARE SOUP TUREEN AND COVER
were made in England, probably in Staffordshire,
between 1815 and 1820. The shape of the tureen
closely resembles one first made by Wedgwood
c.1785. In the 18th and early 19th centuries, it was
common for factories to copy each other – there was
less need to invest money in new designs when
someone else's success could be copied. Wedgwood
prided itself on its originality, however, and would
not resort to copying another factory's designs.

KNOWN AS THE "GOLDFINCH" PATTERN, THIS TRANSFER
print was inspired by Thomas Bewick's A History of
British Birds, *published in 1797. In the early 19th*
century, growing prosperity led to leisure time, and
many people studied nature. The background of the
print is solid blue and the borders a deeper blue;
the borders are part of the transfer print and were
created by stipple engraving. The tureen finial and
moulded decoration around it were probably painted
with cobalt to provide the rich deep blue.

Width 17¼in/44cm £B

British scenery patterns I

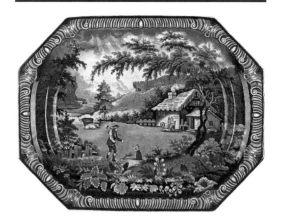

MADE BY BRAMELD & CO. IN YORKSHIRE,
*between 1826 and 1842, this octagonal earthenware
dish has an impressed mark on the back that reads
"Brameld". The factory, which started out as the
Swinton Pottery in the mid-18th century, later
became known as the Rockingham factory. By the
late 18th century, the area was burgeoning with
successful potteries, and they shipped wares abroad.*

THE BRAMELD POTTERY DEPENDED ON FOREIGN MARKETS,
*and when creditors abroad would not pay
in 1825, the company was forced to declare itself
bankrupt. It was rescued by the Earl Fitzwilliam and,
with his financial support, became a porcelain factory,
producing items that were patronized
by royalty and the aristocracy. The porcelain was
sophisticated, ornate and highly decorated.
Nonetheless, the pottery continued to produce
earthenwares, including this dish with the
"Returning Woodman" pattern – it presents a
romanticized view of country life.*

Width 21½in/54.5cm £C

British scenery patterns II

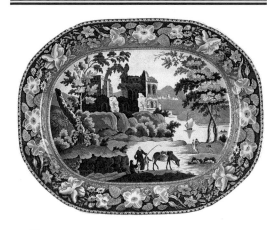

ONE RESULT OF THE INDUSTRIAL REVOLUTION
was that the middle classes were much wealthier. They
had more time on their hands, which meant more
opportunity to travel. The market was flooded with
new travel books filled with engravings of the
most scenic spots. This interest in the landscape was
coupled with one in history, a result of the popularity
of historical novels by such writers as Sir Walter Scott.
The ceramics industry picked up on the
"cult of the picturesque", and provided the market
with pottery in the fashionable taste.

THE TRANSFER PRINT ON THIS BRITISH EARTHENWARE
serving dish, c.1820–40, is an example of what was
fashionable. Although this view cannot be identified,
every major pottery produced series of views,
many of them named. The blue and white palette
declares a Chinese stylistic ancestry, but the
design does not otherwise rely on any Chinese design
or iconography. It is a completely European
scene designed to appeal to European taste.

Width 18¾in/47.5cm £B

Stone china

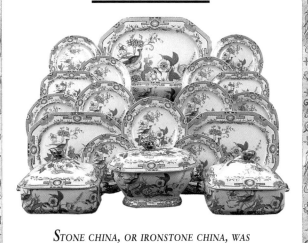

Sᴛᴏɴᴇ ᴄʜɪɴᴀ, ᴏʀ ɪʀᴏɴsᴛᴏɴᴇ ᴄʜɪɴᴀ, ᴡᴀs
*invented by the Staffordshire potters to imitate
Chinese porcelain. John Turner of Land End
first patented it in 1800, and "Turner's Patent" was
marked on all his relevant wares. The new
body was hard, resonant and strong.*

Sᴘᴏᴅᴇ ᴅᴇᴠᴇʟᴏᴘᴇᴅ ᴀ sɪᴍɪʟᴀʀ ᴛʏᴘᴇ ᴏꜰ ʙᴏᴅʏ ɪɴ 1805–07, ᴀɴᴅ
*in 1813, the Mason's factory at Stoke-on-Trent
registered its own patent for "Mason's Patent
Ironstone China". Both factories based the shapes
and transfer prints of their wares on Chinese
porcelain. Not all production was blue and white;
often the transfers were coloured to give the
appearance of Chinese* famille rose *porcelain. Other
Staffordshire makers made their own equivalent
products. Various marks appear on the wares,
including "Stone China", "Opaque China" and
"Ironstone". The dinner service shown here was
made by Hicks, Meigh & Johnson (1822–35), who
used "Stone China" to describe its wares.*

Width largest piece 21½in/54.5cm £D for 73-piece service

Botanical patterns

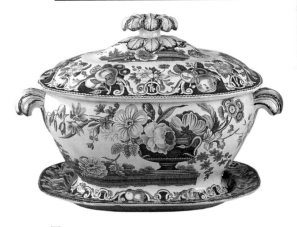

THIS TUREEN IS FROM A SERVICE MADE IN 1820–30 by the Davenport factory at Longport in Staffordshire. It is marked with the factory's impressed trademark of their name above an anchor. The mark used lower-case letters until 1815; afterward, it used upper-case letters. MUCH OF THE FACTORY'S PRODUCTION CONSISTED OF earthenwares. Early printed patterns included slightly clumsy ones such as the "Chinoiserie Ruins". In the early 19th century, however, the factory achieved a level of excellence exemplified by this tureen. Its earthenware body is a strong, light and resonant type of stone china, and it is tinted with cobalt to give it the blue-grey appearance of Chinese porcelain. While the tureen was designed to emulate Chinese imports, the printed decoration of botanical prints is a reinforcement of European taste, as is the shape of the piece, which is modelled on an English original.

Width 13¾in/35cm £B

Exotic Oriental patterns

THE "EASTERN STREET Scene" pattern is printed on this plate, which was made by J. & R. Riley of Burslem in Staffordshire in the early 19th century.

AT THE TIME, the British public was seemingly insatiable in its demand for exotic scenes decorating blue and white earthenwares. It probably sprang from the fact that they had become accustomed to them on porcelain imported from China, which was exotic in its own right. In response, the British potteries began manufacturing their own wares in an increasing variety of patterns, and competition between the factories was fierce.

THE SOURCES FOR THE TRANSFER PRINTS IMPROVED. Artists were travelling abroad more widely than they ever had done before, and the results of their labours – their sketches – were often engraved and published, providing an ideal source of inspiration for the potters.

INDIA, THE JEWEL IN THE CROWN OF THE BRITISH EMPIRE, was a favourite location. The print on this plate is a composite print drawn from two separate engravings, both made in India. The source book, T. and W. Daniell's Oriental Scenery, was published in the late 18th century.

Diameter 9¾in/25cm £A

Spode patterns I

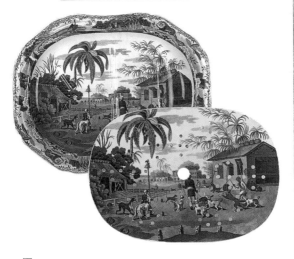

THIS EARTHENWARE SERVING DISH, COMPLETE WITH
an oval drainer, is from a dinner service that
included many pieces. It is transfer printed in blue
with a scene from "The Indian Sporting Series" by
Spode, which was first produced c.1816. The scene is
taken from the 1807 book Oriental Field Sports,
Wild Sports of the East *by Thomas Williamson. This*
particular scene, No. 1 of the 17 used, is of
"Dooreahs or Dog Keepers Leading Out Dogs".

MANY COLLECTORS VIEW THIS SERIES AS THE FINEST
representation of transfer printing on earthenware.
The subjects are original and exotic and the
compositions are arresting. The engraving is of
superb quality, subtle and clear, with variations in
colour and tone. The blue is neither too dark, intense
and smudgy, nor too light and insubstantial. The
earthenware is of beautiful quality, with a good
cream colour and a blue-tinted glaze.

Width 19in/48cm £C

Spode patterns II

In the early 19th century, the Spode factory in Staffordshire made many fine patterns, which were often based on the work of artists. The Spode engravers were highly skilled in interpreting paintings and engravings, using stipple engraving, hatching and different depths of line. The designs were precise, yet subtly shaded, with varying intensities of blue. It was the quality of this work and the wares themselves that earned Spode its good reputation.

Both of these Spode plates are transfer printed in underglaze blue and show compositions of ruined buildings in landscapes that appealed to the early 19th-century taste for the picturesque. The plate above is the famous "Italian" or "Blue Italian" pattern, first produced in 1816 and still being made today. The plate at right shows the "Castle" pattern, introduced in 1817; it resembles another pattern, the "Tower", which dates from 1814 and is still in production.

These patterns are popular with collectors, and there are pieces of all ages on the market – but it is easy to judge the age of a piece by checking the marks in a mark book.

Diameter 9¾in/25cm £A each

Spode patterns III

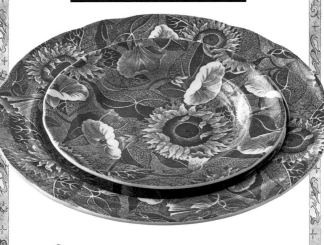

SPODE IS CREDITED WITH THE INVENTION OF underglaze blue transfer printing on earthenwares. At first, transfer printing could only be overglazed and fixed with a low-temperature firing, but the decoration had a tendency to wear off. Printing in underglaze blue was first successful on porcelain at Worcester. Earthenwares presented technical problems (the blue blurred when fired), but the Spode factory succeeded in 1784. The early prints were not perfect – joins between the transfers may be evident – but they paved the way for later successes.

THE "SUNFLOWER" PATTERN ON THIS SPODE DISH AND PLATE was first produced in 1816. It is a "sheet" pattern: the central panel and the border are both part of the same transfer, so it is easier to apply than separate transfers. When made today, some pieces are transfer printed using the original technique, while others are printed by a modern lithographic process. The shape of the wares dictates the method.

Diameter plate 11½in/29cm £A

Moorcroft pottery

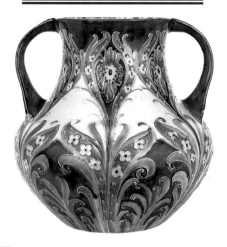

WILLIAM **M**OORCROFT JOINED **J**AMES **M**ACINTYRE
*& Co. at Burslem, Staffordshire, in 1897. He became
the chief designer and developed an individual
style, which is exemplified in this vase. It shows
elements of the Art Nouveau influence, yet retains the
classic symmetry of older traditions, including
those of China and the Middle East.*

*E*VEN TO THE UNTRAINED EYE, IT IS OBVIOUS THAT THIS
*piece was made by hand. These wares were successful
in Great Britain in the late 19th and early
20th centuries, when the public wanted objects that
did not look factory made. The piece, once
thrown and turned, was dipped in a coloured slip; the
design was then tube-lined on to the surface by
a trained decorator (a process similar to squeezing
toothpaste out of the tube). After firing, the
piece was glazed in different-coloured glazes and
fired again. The wares came in a variety of
colours, including blue and white.*

Height 8in/20cm £C

Royal Doulton

THE FACTORY KNOWN AS Royal Doulton started out making stoneware. John Doulton established it in Lambeth in the early 19th century, and the business was expanded by his son, Henry. Initially, they were makers of utilitarian wares and water pipes, but they branched out into artistic stonewares and art pottery in the mid-19th century. The workshops were staffed by decorators from the Lambeth School of Art, who worked under artistic directors. The factory received commendations at successive international exhibitions in the 1870s.

THE RANGE OF WARES PRODUCED IS ALMOST BEWILDERING in its diversity, and the company even began to make porcelain in 1882. This early 20th-century vase is from the "Blue Children's Ware" range. It is transfer printed in blue; the transfers allow the industrial production of wares that look convincingly as if they had been hand painted. Eventually, what had started out as a factory producing handmade art pottery became a mass-production company, although innovation is still a hallmark.

Height 9in/23cm £B

American wares

European immigrants arriving in the United States in the 1600s brought with them their skills in producing lead-glazed earthenwares. However, the American ceramics industry had a slow start and could not supply the demands of its domestic market. In the 18th century, the country relied on Europe for delftware and porcelain.

A FACTORY MAKING ENGLISH-STYLE SOFT-PASTE PORCELAIN was established at Philadelphia in 1770. It made elegant blue and white porcelain similar to that made at the Bow factory in England. But the factory closed after only two years. Creamwares enjoyed greater success, and many factories were in production by the early 19th century.

STONEWARE TOOK HOLD OF THE MARKET EARLY ON AND lasted into the 19th century. It was being made in Philadelphia as early as 1730 by a Huguenot potter, Anthony Duche, using local clay. The wares he made followed traditional English and German shapes. This puzzle jug, based on an English creamware or delft example, was made c.1860. Holes in the neck and several spouts made pouring the liquid without spilling it a challenge.

Height 6½in/16.5cm £D

Cornish Ware

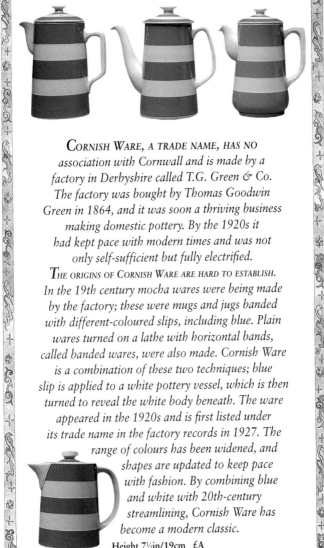

Cornish Ware, a trade name, has no
association with Cornwall and is made by a
factory in Derbyshire called T.G. Green & Co.
The factory was bought by Thomas Goodwin
Green in 1864, and it was soon a thriving business
making domestic pottery. By the 1920s it
had kept pace with modern times and was not
only self-sufficient but fully electrified.

The origins of Cornish Ware are hard to establish.
In the 19th century mocha wares were being made
by the factory; these were mugs and jugs banded
with different-coloured slips, including blue. Plain
wares turned on a lathe with horizontal bands,
called banded wares, were also made. Cornish Ware
is a combination of these two techniques; blue
slip is applied to a white pottery vessel, which is then
turned to reveal the white body beneath. The ware
appeared in the 1920s and is first listed under
its trade name in the factory records in 1927. The
range of colours has been widened, and
shapes are updated to keep pace
with fashion. By combining blue
and white with 20th-century
streamlining, Cornish Ware has
become a modern classic.

Height 7½in/19cm £A

Glossary

BISCUIT Unglazed pottery that has been fired once.

CERAMICS Any object, such as earthenware, porcelain or stoneware, made from fired clay.

COBALT A blue colour, created when the mineral ore cobalt aluminate is added to a glaze.

CHINA CLAY *see* kaolin.

CHINOISERIE Mid-18th century style of decoration, inspired by Chinese and Oriental decoration and design.

DELFT Tin-glazed earthenware. Known in Holland as Dutch Delft, in other countries as delft.

EARTHENWARE Pottery made from clay, refined or otherwise, and fired at a low temperature.

FAIENCE (OR FAYENCE) Tin-glazed earthenware.

GLAZE A glassy coat on the surface of a ceramic body.

HARD-PASTE PORCELAIN "True" porcelain, made from kaolin. When fired, it produces a fine white body.

IRONSTONE *see* stone china.

KAOLIN China clay, a naturally occurring clay, which is used to make hard-paste porcelain.

LEAD GLAZE A glaze in which lead is the main fluxing agent.

MANGANESE A purple or brown colour, created when the mineral ore manganese oxide is added to a glaze.

PASTE A term generally used to describe a clay body.

PORCELAIN A pottery body that is usually white, resonant and translucent (*see* hard-paste and soft-paste porcelain).

POTTERY All objects, including earthenware, stoneware and porcelain, made from fired clay.

SALT GLAZE A thin, clear glaze created when salt is thrown into the kiln and vapourizes.

SOFT-PASTE PORCELAIN Artificial porcelain, made by mixing refined white clays and sometimes ground glass, or frit.

SLIP A liquid clay used as a finish or a decoration.

SOAP ROCK *see* steatite.

STEATITE Hydrated silica of magnesium; commonly called soap rock, soapy rock and soapstone. Used to make soft-paste porcelains.

STONE CHINA A type of strong, durable earthenware.

STONEWARE A hard, dense non-porous pottery, fired at a high temperature.

TIN GLAZE An opaque white glaze made from the basic lead glaze mixed with tin oxide.

TRANSFER PRINTING To apply a decoration, paper with a print of the design in metallic oxides is wrapped around the piece; the paper burns off when fired.

WHITE CLAY Clay that is light in colour and free of impurities.

Index

Acknowledgments

All pictures courtesy of Christie's Images except for the following:
Christie's South Kensington: 74.
Christopher Wood Gallery, London/Bridgeman Art Library: 9.
Clive Corless/Marshall Editons: 37, 47.
Richard Dennis Publications: 77.
Spode, Stoke-on-Trent: 8, 10, 73.
Victoria & Albert Museum: 27.
Illustrators: **Lorraine Harrison** (borders), **Debbie Hinks** (endpapers).